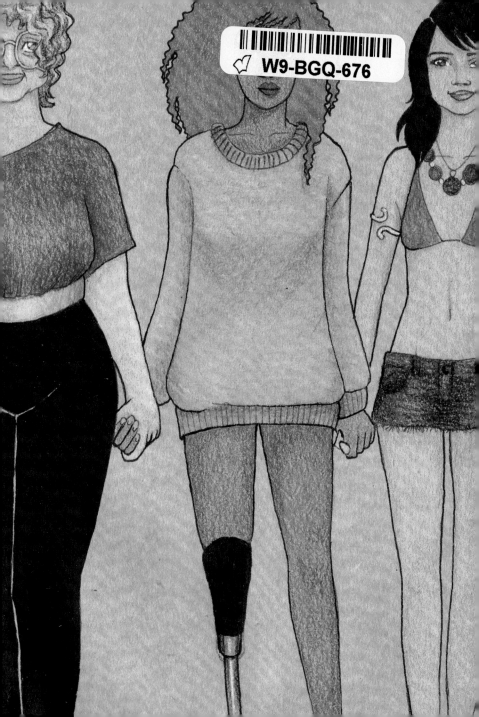

WOMEN

~

BODY-POSITIVE ART
TO INSPIRE AND EMPOWER

WOMEN

~

BODY-POSITIVE ART TO INSPIRE AND EMPOWER

Carol Rossetti

Skyhorse Publishing

Skyhorse Publishing books may be purchased in bulk at special discounts for sales promotion, corporate gifts, fund-raising, or educational purposes. Special editions can also be created to specifications. For details, contact the Special Sales Department, Skyhorse Publishing, 307 West 36th Street, 11th Floor, New York, NY 10018 or info@ skyhorsepublishing.com.

Skyhorse® and Skyhorse Publishing® are registered trademarks of Skyhorse Publishing, Inc.®, a Delaware corporation.

Visit our website at www.skyhorsepublishing.com.

10 9 8 7 6 5 4 3 2 1

Library of Congress Cataloging-in-Publication Data is available on file.

Cover design by Brian Peterson
Cover illustration by Carol Rossetti

Print ISBN: 978-1-63450-250-4
Ebook ISBN: 978-1-5107-0076-5

Printed in China

To my beloved.

TABLE OF CONTENTS

Introduction

The Women Project is one of the most amazing things that has ever happened to me. When I started a new illustration project (mostly as an excuse to make a drawing every day), I had no idea what was coming. Hundreds of people identified with the women I created, and my Facebook page became a place where women from all over the world could share stories and ideas.

People have asked me plenty of times if I'm a feminist. Yes, I am. But that seems pretty vague nowadays, doesn't it? There are just so many ways to be a feminist and so many ways to fight oppression that the word has become, perhaps, too wide. So yes, I do identify as a feminist, but I think it's important to explain how I understand the movement, as well as my approach to fighting this fight.

I identify with the ideas of intersectional feminism, which means that I don't think it's enough to fight sexism *per se*. I think the fight is only efficient if it's for an inclusive and safe environment for all women. For that to happen, other issues must be taken into consideration and be seen as inseparable from feminism. People of color need to be included, and racism must be fought. People with disabilities must be included, and ableism must be fought. Trans people must be included, and transphobia must be fought. Gay, lesbian, bisexual, pansexual, asexual, aromantic people need to be included, and sexual diversity must be defended. Poor, hungry, homeless, illiterate people need to be included, and social inequality must be fought. People with mental illness must be included, and the stigma they carry must be fought as well.

Representation is a big issue inside feminism. How wide should it be? Who should feminism include or exclude? Who can actually have a say in how this fight should be fought? Should men be heard as well? Should people be more heard the more oppressed they are?

I don't have any answers for these questions. I'm not the person who will say what feminism is or is not about. I have *a* voice, but I'm not *the* voice of the movement. I can only speak on how I've decided to fight for a better world through my work, and I really want to make it clear that my way is not the only valid way.

One of my favorite authors, José Saramago, once said: "I learned not to try to convince anyone. The work of convincing is a lack of respect; it's an endeavor of colonizing the other [*Aprendi a não convencer ninguém. O trabalho de convencer é uma falta de respeito, é uma tentativa de colonização do outro*]." In my opinion, it's one of the wisest things anyone has ever said, and also one of the hardest to truly acknowledge. So here's my proposition: let's talk and learn, but let's not try to colonize each other.

My approach has always been inclusion. Of course there are many people who haven't been represented in my work, and I can't bring visibility to everybody on my own. But I do my best to represent different people and to inspire others to widen the representation of the human being in their own works.

As for the themes, I try to approach a large diversity of issues. Not all illustrations will be socially relevant everywhere. A theme can be, at the same time, a bold topic in some countries and something trivial in another. The project became international, and therefore not all themes will be equally relevant to all cultures. Still, it's important to know about fights other than our own.

Some women are in a situation of more vulnerability than others. Black women face more violence than white women, trans women face more violence than cis women, and a black trans lesbian woman will face an even tougher daily challenge. Some things are more urgent than others. It's only natural and important that activism establishes fighting priorities. I try to discuss these serious matters, but the fact that we have urgent topics doesn't mean we can't talk about other themes as well. I think it's important to include the small things, the ones we don't always take seriously in our routine, but

that bother us, and end up being part of a much larger issue of control over our bodies, behaviors and identities.

As the title *WOMEN* suggests, I chose to draw only female characters for this project. This decision was partially motivated by a personal identification. But it's not a project exclusively about women, or only for women, and even less about all women at the same time. Not all the situations I portray are lived only by women, and I welcome men (or people of any other gender) to identify as well. Besides, I find it interesting to awaken in men the chance to identify with female characters. I remember that when I was a kid, it was common that the movies, books, and animations starring female characters were seen as "for girls," while stories with male characters were "for everyone." The fact that my protagonists are women does not make this a project just "for girls."

I have received several messages on my social networks from men, telling me that they have learned a lot from my work. Some even said that it was through my page that they realized that they had been disrespectful to women and wouldn't make that same mistake again. Nevertheless, I also got messages from women saying that they noticed they were being judgmental toward their sisters for their personal choices, and therefore were contributing to a system of control over feminine autonomy; and so they started to rethink their own comments.

I believe that's a very positive effect of my work, and that's only possible if people who are not necessarily aware of the discussions inside the activist movements are able to comment, ask, share their experiences, and join constructive dialogues. At this point, many have said I should ban people from the page and erase offensive comments (and I did erase some of the comments from people who were very aggressive and disrespectful to others). However, if I were to exclude everyone and anyone who said something wrong out of ignorance, only those who were already informed about these fights would remain on the page. That's not the goal of my project. I'm looking for dialogue, discussions, so that people learn from each other's words and experiences. We won't change the world if we keep the discussion within a small group of activists.

I'm not saying we all have the responsibility to explain the basic principles of the fight against sexism, racism, homophobia, and so many other

oppressions. Many people can't stand to do this anymore. I know women who are tired and angry, and they have every right to be. Many of them have been traumatized, harassed and disrespected, and have no energy left to say the same things thousands of times. Nobody has the obligation to introduce to others the basic fundaments of activist movements, but the way should be open to those who wish to do it.

There are black, white, brown, Latin, Asian, African, Indian, indigenous women. There are blind, deaf, mute women. There are bipolar, depressed, suicidal, anxious women. There are engineers, housewives, prostitutes, politicians, artists, executives, and porn stars who are women. There are lesbians, bisexuals, aromantics, pansexuals, asexuals. There are trans, genderfluid, binary, non-binary, intersex people. There are women who experience three orgasms every day and women who have never achieved one. Women who wear tons of makeup, women who can't stand lipstick, who don't do their nails, who don't sunbathe ever, and women who choose to have a thousand plastic surgeries. There are women who want to dedicate their lives to their families, and women who have no wish to build a family of their own. There are women who like romantic comedies and women who like horror movies, and women who like both. Women who wear pink and women who wear black. There are Christian women, Muslim women, Jewish women, atheist women, agnostic women, and Buddhist women. There are women who are not activists, who have never heard of feminism, who have never discussed racism. There are women who are ashamed of sharing their choices because they fear they will be judged. And there are women who disagree with everything I've said so far.

There are so many different women in the world that I could go on forever. Each one has her own story, and I believe they all deserve to be heard and represented. My approach will be wide, making everybody comfortable getting to know the feminist movement and all of its strands, welcoming anyone who shares with me this idea of freedom to celebrate the diversity of the human kind. Come on in, have some coffee, and find a seat. Everybody is invited.

Body

Today, the female body is under constant watch. Women's bodies have been controlled in such a deep and effective way that often times we don't even notice it's happening. We are regulated by a cruel standard of physical perfection, with potentially devastating effects.

Throughout life, women are led to believe that they can only achieve real success if they're perceived as beautiful. Intelligence and talent don't seem to make much of a difference when the media is only interested in criticizing women's clothes, body hair, and silhouettes. The first thing to be analyzed in a woman is always and inevitably her looks.

I want to deconstruct this idea with my *Women* illustrations. There isn't a single way to be beautiful, and neither should our looks be the focus of our self-esteem. No one should be constantly monitored and evaluated based on her looks—especially up to such standards—and the pressure needs to end. Shaving, elegance, diets, and makeup: all of these are choices, never obligations. Women should have full control over their own bodies!

AMANDA HAS DECIDED THAT SHAVING IS NOT HER THING.

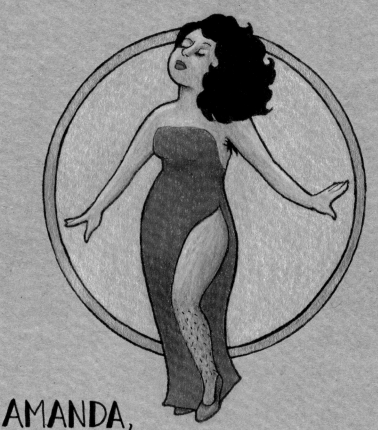

AMANDA,
it's **YOUR BODY** AND YOU DO WHATEVER YOU WANT WITH IT. NO SOCIAL CONVENTION SHOULD HAVE A SAY IN YOUR **IDENTITY!**

DEBORA LOVES HER SMALL BREASTS WHILE DANIELE HAS CHOSEN TO UNDERGO BREAST AUGMENTATION.

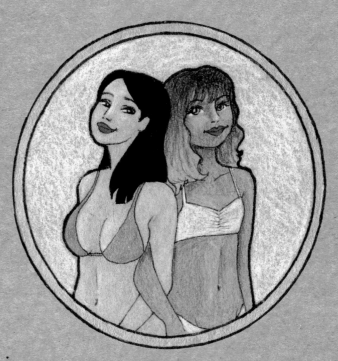

GIRLS,
THE CHOICE IS YOURS!
IT IS YOUR BODY AND YOU SHOULD DO WHAT MAKES YOU HAPPIEST!

GABRIELA IS A BODYBUILDER, AND PEOPLE OFTEN SAY THAT SHE IS "RUINING HER BODY."

GABRIELA, JUST IGNORE THOSE WHO TRY TO MAKE YOU FEEL BAD ABOUT FOLLOWING YOUR DREAM. IT'S YOUR BODY, YOU ARE THE ONE WHO SHOULD ENJOY IT!

JANE WAS TOLD THAT SHE WOULD BE **REALLY PRETTY** IF SHE LOST A **FEW** POUNDS.

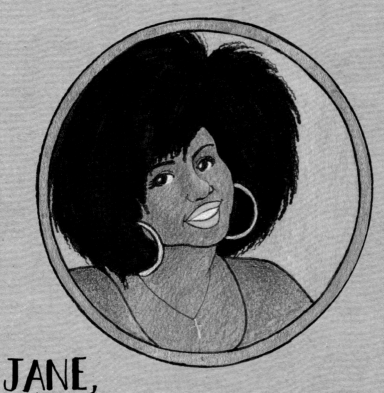

JANE,

YOUR BEAUTY AND YOUR **SELF-ESTEEM** ARE NOT DEFINED BY YOUR WEIGHT.

(AND IT'S LIKELY THAT THOSE WHO SAID THAT WOULD BE PRETTIER IF THEY KNEW WHEN TO SHUT UP).

JESSICA HAS ALWAYS BEEN SKINNY AND USED TO GET UPSET WHEN SHE HEARD PEOPLE SAYING "REAL MEN LOVE CURVES."

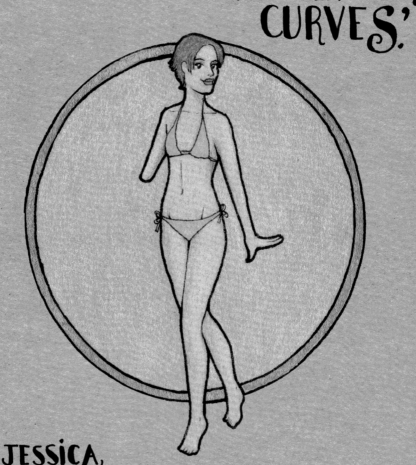

JESSICA, YOUR BODY IS NOT THERE FOR "REAL MEN TO LOVE". YOU DON'T HAVE TO DO ANYTHING TO PLEASE ANYONE BUT YOURSELF.

MAÍRA LOVES HER AFRO!
BUT RUMOR HAS IT THAT HER HAIR IS
UGLY, WIRY, KINKY, NAPPY, BAD.

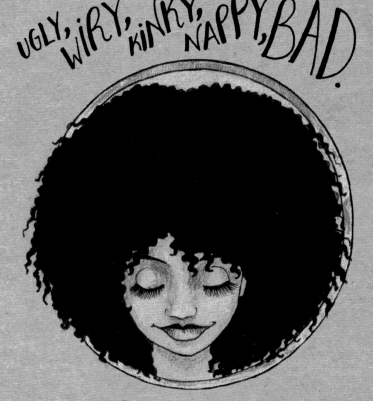

MAÍRA, DON'T STRAIGHTEN IT JUST BECAUSE OF THAT.
YOUR HAIR IS
MEMORY, ANCESTRY, STRENGTH,
BEAUTY, IDENTITY & TONS OF LOVE!
YOUR HAIR, BESIDES BEING GORGEOUS, IS YOURS.
YOU ARE IN CHARGE.

AT **SAMANTHA'S** SON'S 3-YEAR OLD BIRTHDAY PARTY, AN AUNT ASKED HER: "**HAVEN'T YOU OUTGROWN** THIS **HAIR COLOR?**"

NO. YOUR **FREEDOM** HAS NO EXPIRATION DATE, **SAMANTHA!**

SILVIA HAS WHITE HAIR.
PEOPLE HAVE BEEN TELLING HER TO DYE IT,
SO SHE DOESN'T LOOK OLD.

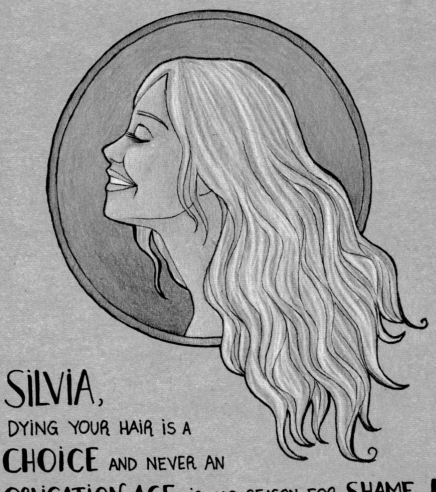

SILVIA,
DYING YOUR HAIR IS A
CHOICE AND NEVER AN
OBLIGATION. AGE IS NO REASON FOR SHAME.
YOUR HAIR IS BEAUTIFUL AND THE CHOICE IS YOURS!

TATIANA SOMETIMES FEELS **ASHAMED** OF HER BODY BECAUSE SHE HAS **CELLULITE**.

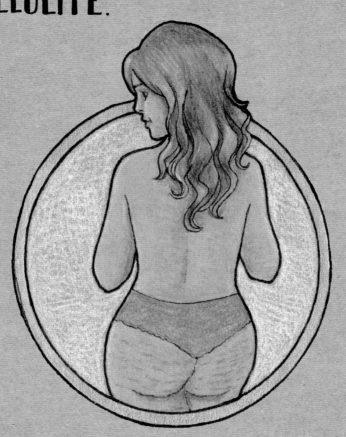

TATIANA, SOMETHING SO **NATURAL** AND **HARMLESS** SHOULD NOT BE A REASON FOR FEELING **EMBARRASSED**.

ANDRESSA, TAINÁ, LIZ & LUANA ALL HAVE SEVERAL **TATTOOS.** THEY HAVE, AT TIMES, HEARD THESE TATTOOS ARE A SIGN OF **PROMISCUITY.**

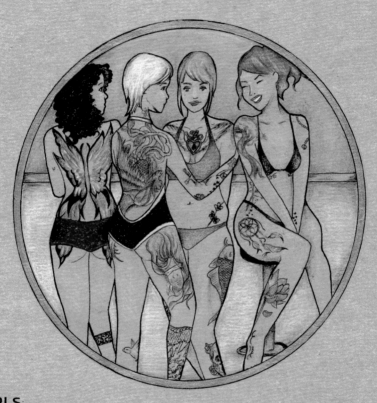

GIRLS,
DON'T WORRY.
GO AHEAD AND PAINT YOUR **BODY** HOWEVER YOU WANT AND **SLEEP** WITH WHOMEVER YOU WANT; TATTOOS WILL CONTINUE TO HAVE NO CORRELATION WITH **SEXUALITY.**

WHITNEY HAS SPENT 10 YEARS OF HER LIFE
TRYING TO LOSE WEIGHT SO SHE COULD BE HAPPY.
THEN, SHE REALIZED HER BODY DIDN'T STOP HER FROM
DOING WHAT SHE LOVES AND TRYING TO FIND
HAPPINESS.

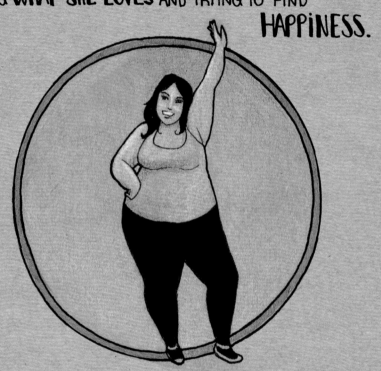

THAT'S THE WAY, WHITNEY!
YOU DON'T HAVE TO ALLOW AN EXCLUDING
AND DISCRIMINATING STANDARD BE PUT BETWEEN
YOU AND YOUR HAPPINESS.
EVERYBODY IS ENTITLED TO
INNER LOVE!

WHEN **OLIVIA** LOST HER **HAIR,**
SHE THOUGHT SHE WOULD NEVER DARE
GO OUT WITHOUT HER **WIG.**

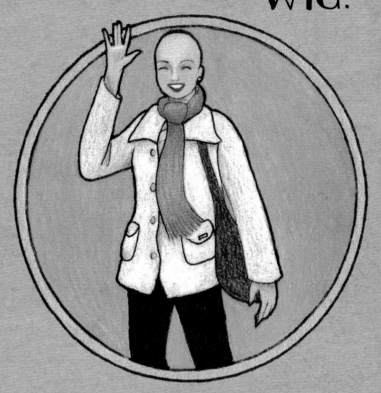

BUT IT'S BEEN SOME TIME NOW,
AND **OLIVIA** HAS COME TO **LOVE** HERSELF
AGAIN AND FIND HER BEAUTY REGARDLESS
OF HER WIG. THERE'S SO MUCH
FREEDOM IN **INNER LOVE,**
ISN'T THERE, **OLIVIA?**

IT TOOK **LORENA** A **LONG TIME**
TO FIND HER **SENSUALITY** BECAUSE SHE HAS
NEVER SEEN HERSELF REPRESENTED AS **BEAUTY**,
ONLY AS **TRAGEDY.**

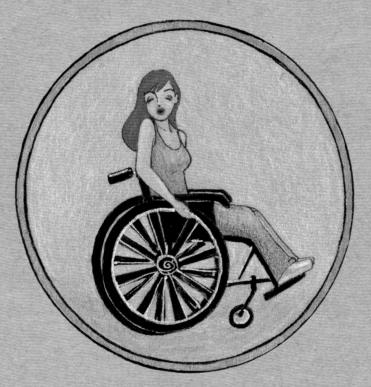

BUT **YOU ARE** SO MUCH MORE THAN THE WAY
THE **MEDIA** PORTRAYS YOU, AREN'T YOU, **LORENA?**
YOUR WHEELCHAIR IS **FREEDOM** AND IT CAN
RUN OVER ANYONE WHO REDUCES YOU TO
STEREOTYPES.

MAYA HAS BEEN TOLD THAT SHE WOULD BE GORGEOUS IF HER SKIN WASN'T SO DARK.

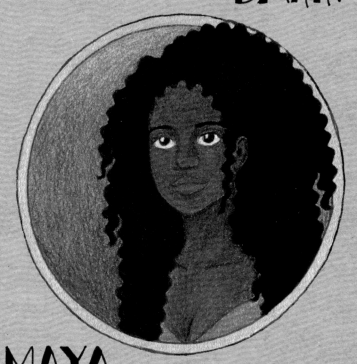

MAYA, SKIN TONE DOESN'T DEFINE BEAUTY OR UGLINESS, BUT CAN SURELY REVEAL RACISM IN SOME PEOPLE. YOU ARE BEAUTIFUL JUST THE WAY YOU ARE!

ALANNA HAS A BIG BIRTHMARK ON HER NECK AND SPENT HER YOUTH TRYING TO HIDE IT.

BUT ALANNA LEARNED TO RELAX, AND NOWADAYS HER MARK DOESN'T MAKE HER UNCOMFORTABLE ANYMORE.

EVEN THOUGH SHE HATES **SUNBATHING,**
FLORA HAS BEEN TOLD SEVERAL TIMES TO
"**GET A TAN**" SO SHE DOESN'T LOOK SO
"**SICKLY PALE**."

FLORA,
YOU DON'T HAVE **ANY** OBLIGATION TO PLEASE
THE EYES OF **OTHERS** BY DOING SOMETHING
YOU DON'T LIKE. **YOUR BODY** IS
NOBODY ELSE'S BUSINESS!

LIV USUALLY HAS PIMPLES ON HER FACE. SHE HAS LOST COUNT OF HOW MANY TIMES RANDOM PEOPLE HAVE TOLD HER SHE SHOULD "HANDLE THIS PROBLEM."

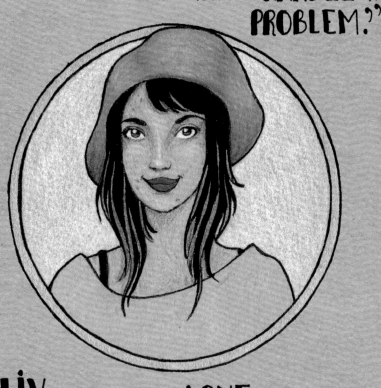

LIV KNOWS THAT ACNE IS SOMETHING NATURAL AND DOESN'T UNDERSTAND WHY OTHER PEOPLE ARE SO WORRIED ABOUT SOMETHING ON HER SKIN THAT DOESN'T EVEN BOTHER HER THAT MUCH.

PALOMA HAS ALBINISM,

AND SHE HAS BEEN TOLD BY SOME PEOPLE SHE IS "GOOD LUCK", AND BY OTHERS THAT SHE IS "BAD LUCK."

PALOMA, YOU ARE A HUMAN BEING AND NOT AN AMULET. YOUR SKIN PIGMENTATION IS NOBODY ELSE'S BUSINESS.

JULIANA HAS HEARD THAT SHE ONLY BECAME A CEO BECAUSE SHE'S VERY PRETTY.

SURELY YOUR YEARS OF EXPERIENCE AND PhD HAVE NOTHING TO DO WITH IT, RIGHT, JULIANA?

GIOVANA HAS BEEN CRITICIZED FOR HAVING A LOT OF **PLASTIC** SURGERIES THAT **CHANGED** HER **FACE.**

GIOVANA, THE FEATURES YOU DECIDE TO **CHANGE** OR **KEEP** ARE **YOUR** DECISION. YOUR SURGERIES ARE **NOT** AN INVITATION FOR PEOPLE TO TELL YOU WHAT YOU SHOULD OR SHOULDN'T DO WITH **YOUR BODY!**

DURING HER ADOLESCENCE, **SANDRA** GREW UP **TOO FAST** AND GOT MANY **STRETCH MARKS** ON HER BODY.

HER **MOM** TOLD HER NOT TO WORRY ABOUT IT, BECAUSE **SANDRA** WAS LIKE A **YOUNG TIGRESS** GETTING HER STRIPES, AND THAT WAS NO REASON FOR **SHAME.**

MIRA WAS CRITICIZED BY MANY WHEN SHE DECIDED TO HAVE **BREAST REDUCTION** SURGERY.

MIRA, IT'S **YOUR BODY** AND YOU'RE THE **ONLY ONE** WHO CAN DECIDE WHAT'S **BEST** FOR **YOU!**

JUST THE OTHER DAY,
SOMEONE ASKED **LANA** iF SHE WAS
ASHAMED TO WALK AROUND iN **SHORTS.**

NO, LANA is **NOT** ASHAMED OF
HER **BODY AT ALL.**
SHE THINKS THIS APPROACH iS ANYTHING
BUT RESPECTFUL.

LIGIA THOUGHT SHE WOULD NEVER GO TO THE BEACH IN A BIKINI AGAIN BECAUSE OF THE SURGERY SCAR ON HER BELLY.

BUT IT'S BEEN SOME TIME AND LIGIA DOESN'T FEEL BOTHERED BY HER SCAR NOW. SHE HAS LEARNED TO IGNORE THE INDISCREET LOOKS SHE GETS SOMETIMES.

LAYLA AND MIA HEARD THAT THEY SHOULD LOVE THEIR FRECKLES BECAUSE "MANY MEN ARE CRAZY ABOUT THEM".

THEY DO **LOVE** THEIR FRECKLES, BUT DON'T SEE THE **PERKS** IN BEING CONSTANTLY **FETISHIZED** BECAUSE OF THEM. ATTRACTING **MEN'S ATTENTION** ISN'T THEIR **TOP PRIORITY!**

CLARISSA CAN'T STAND THE "DUMB BLONDE" JOKES AT HER FAMILY REUNIONS.

SOME PEOPLE SEEM TO TAKE SOME SPECIAL PLEASURE IN BEING **DISRESPECTFUL** TO OTHERS UNDER THE **HUMOR MASK**, DON'T THEY, **CLARISSA?** MAYBE ONE DAY THEY'LL REALIZE **NOBODY ELSE** IS LAUGHING.

LINA WAS AFRAID OF HER CLASSMATES' REACTION WHEN SHE HAD TO GET BRACES.

LINA, BRACES ARE NO REASON FOR MOCKING. MANY PEOPLE NEED TO WEAR THEM AND YOU PROBABLY WON'T BE THE ONLY ONE IN YOUR CLASS WHO HAS THEM. YOU CAN SMILE WITH NO SHAME!

Fashion

When associated with the beauty industry, fashion can be very oppressive to women. For my project, I preferred to approach fashion as an instrument of freedom and empowerment, in which wearing a bikini represents inner love and self-esteem.

I see a great potential in fashion to empower women, but only when it respects the many different styles and body types. It's only natural that we want to feel good in our own clothes, but unfortunately, it's not an easy task considering the infinity of rules of what we should or shouldn't do and the limitation of available sizes. My work is an attempt to encourage a more inclusive fashion that values the different bodies and identities, creating possibilities and alternatives for all women.

IT WAS A **VERY HOT** DAY WHEN **EDUARDA** WORE SHORTS TO SCHOOL. THE TEACHER TOLD HER NEVER TO DRESS LIKE THAT AGAIN, BECAUSE THE **BOYS** GOT DISTRACTED DURING **CLASS.**

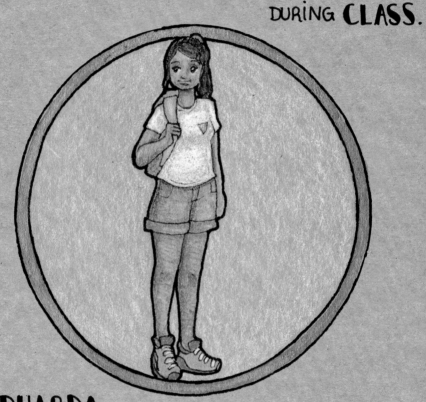

EDUARDA, IT'S NOT **YOUR JOB** TO MAKE OTHER PEOPLE BEHAVE WITH **DECENCY** AND **RESPECT.** YOU SHOULD DRESS HOW YOU FEEL **COMFORTABLE!**

HELENA AVOIDED WEARING HIGH HEELS BECAUSE EVERYBODY TOLD HER SHE WOULD LOOK TOO TALL.

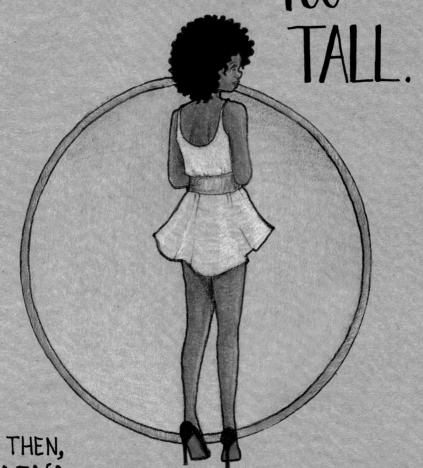

THEN, HELENA TRIED ON THE LOUBOUTINS AND HAS NEVER EVER WANTED TO TAKE THEM OFF.

LAURA ONLY WEARS **LOOSE-FITTED** CLOTHES BECAUSE SHE HAS NEVER FELT COMFORTABLE WITH THE SO-CALLED "**WOMENSWEAR**" COLLECTIONS.

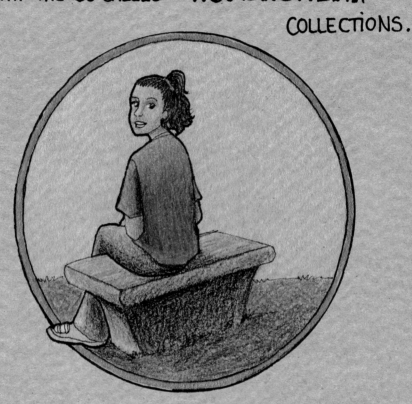

LAURA, CLOTHING DOES NOT DEFINE **GENDER.** EVERYBODY CAN AND SHOULD WEAR WHATEVER FITS THEIR OWN **IDENTITY!** YOU HAVE THE **WHOLE** STORE TO BROWSE FOR THE PERFECT OUTFIT, NOT JUST THE WOMEN'S SECTION.

LYDIA LOVES WEARING MINI SKIRTS, BUT HER BOYFRIEND ALWAYS ASKS HER TO CHANGE INTO SOMETHING MORE CONSERVATIVE.

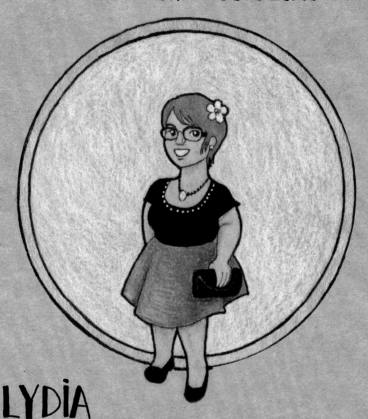

LYDIA THOUGHT IT BETTER TO CHANGE COMPANY AND HANG OUT WITH PEOPLE WHO WON'T JUDGE HER STYLE INSTEAD.

MARINA LOVES HER STRIPED DRESS, BUT THE FASHION MAGAZINES SAID HORIZONTAL STRIPES DON'T FIT HER BODY SHAPE.

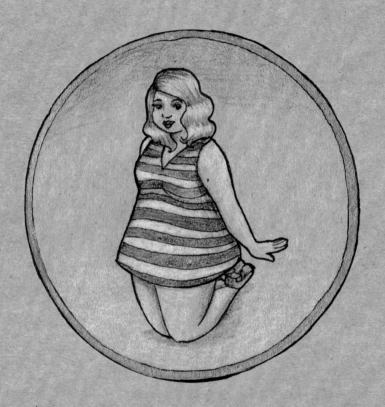

DON'T YOU CARE ABOUT THOSE MAGAZINES, MARINA. THE IMPORTANT THING IS FOR YOU TO WEAR WHAT YOU LIKE, AND TO FEEL COMFORTABLE WITH YOUR OWN BODY.

MARIANA HAS ALWAYS LOVED GOING TO THE **BEACH.** HOWEVER, IT'S BEEN SOME TIME SINCE PEOPLE STARTED BADMOUTHING HER **BODY,** AND THEY EVEN SUGGESTED SHE RETIRE THE BIKINI AND WEAR SOMETHING MORE **DISCREET.**

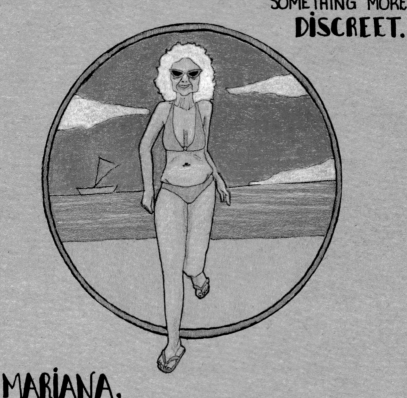

MARIANA, YOUR BODY **IS NOT** AN **ORNAMENT** MADE TO **PLEASE** THE PUBLIC. YOU GO TO THE BEACH **HOWEVER YOU LIKE!** THOSE WHO DON'T APPROVE OF YOUR LOOKS CAN ALWAYS LOOK **THE OTHER WAY.**

URSULA NEVER LIKED WEARING MAKEUP.

THAT'S NOT A PROBLEM, URSULA! YOU ARE THE BOSS OF YOUR FACE!

AFTER 5 YEARS OF FIGHTING AGAINST HER BODY, JOANNA CHOSE TO WEAR A BIKINI AT THE BEACH.

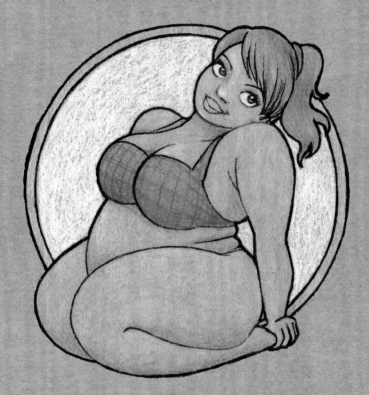

JOANNA HAD A REALLY GOOD TIME AND REALIZED SHE DOESN'T NEED TO CHANGE HER BODY TO FEEL GOOD!

LETICIA CUT HER HAIR REALLY SHORT, AND PEOPLE AT HER WORKPLACE ASKED IF SHE HAD "TURNED INTO A LESBIAN."

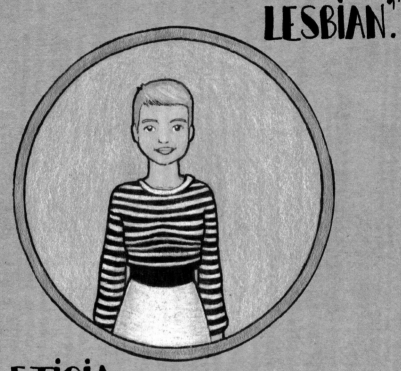

LETICIA, YOUR SEXUALITY HAS NOTHING TO DO WITH YOUR HAIRCUT, AND IT'S SURELY NOT YOUR COWORKERS' BUSINESS!

PRISCILLA WAS AFRAID TO GO OUT IN PUBLIC THE FIRST TIME SHE WORE A DRESS.

THAT DAY TURNED OUT TO BE ONE OF THE BEST IN PRISCILLA'S LIFE, AND SHE NEVER WANTS TO WEAR "MALE" CLOTHES EVER AGAIN!

VIOLET AND ANDREA WERE HARASSED AT AN EVENT BECAUSE OF THEIR COSPLAY CHOICES.

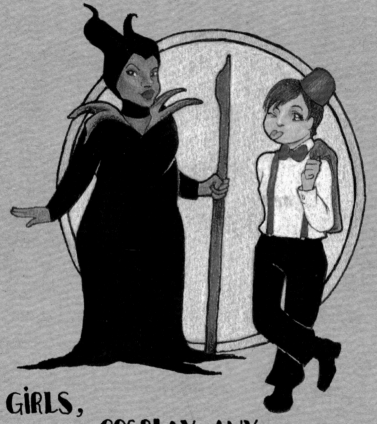

GIRLS, YOU CAN COSPLAY ANY CHARACTER YOU LIKE, AND THAT DOESN'T GIVE ANYONE THE RIGHT TO BE RUDE TO YOU. HAVE FUN, AND DON'T YOU MIND THOSE WHO PREFER TO ANNOY YOU RATHER THAN ENJOY THE EVENT!

MARTHA REALIZED THAT HER BODY HURT A LOT AFTER WEARING A BRA FOR A LONG TIME. SO SHE DECIDED TO GET RID OF THIS PIECE OF CLOTHING FOR GOOD!

THAT'S RIGHT, MARTHA! YOU'RE NOT OBLIGED TO WEAR ANYTHING THAT FEELS BAD FOR YOU.

HEIDI HAS HEARD PEOPLE SAYING THAT WOMEN SHOULDN'T WEAR ANY MAKEUP BECAUSE IT'S A WAY TO "TRICK MEN"

HEIDI WEARS MAKEUP FOR HERSELF AS A WAY OF SELF-EXPRESSION, AND SHE'S NOT ASKING FOR ANYONE'S APPROVAL.

SHIRLEY NEVER LIKED GETTING HER NAILS DONE, AND SOME PEOPLE SAY SHE SHOULDN'T BE "SO CARELESS" WITH HERSELF.

SHIRLEY, DOING YOUR NAILS OR NOT IS ENTIRELY YOUR CHOICE, AND THERE'S NOTHING WRONG WITH GOING WITHOUT THE NAIL POLISH. YOU CAN DO WHATEVER YOU WANT!

ROSARIO WOULD LOVE TO GO **TOPLESS** AT THE BEACH, BUT IS **AFRAID** TO BE **CALLED OUT.**

ROSARIO DOESN'T UNDERSTAND WHY **FEMALE BREASTS** CAN'T BE SHOWN WHEN THEY'RE NOT BEING **SEXUALIZED** ON FILMS OR MAGAZINES.

BIANCA'S FAMILY DOESN'T LIKE HER FASHION SENSE.

BIANCA,
YOU CAN WEAR **WHATEVER YOU WANT**
IN WHICHEVER WAY YOU FEEL COMFORTABLE
AND THAT **BEST** EXPRESSES YOUR **IDENTITY.**

Identity

This section discusses issues that are fundamental to each person, like sexuality, gender, values, and beliefs. These things are important parts of our identity, regardless if we were born this way (in terms of gender and sexuality) or whether we developed these ideas later (like values and beliefs).

I also like to question some expectations towards gender, age, and behavior that can be quite limiting to some people. The goal here is to encourage everyone to accept his or her own identity and feel safe to express it. Nobody should be judged simply for being who they are.

ALINE IS BISEXUAL. PEOPLE OFTEN SAY THERE'S NO SUCH THING AND SHE'S REALLY JUST CONFUSED.

IF SHE'S NOT "ALIGNED" WITH THESE PEOPLE'S THOUGHTS, IT'S ONLY BECAUSE THE LOVE ALINE FEELS OVERFLOWS LABELS. YOUR SEXUAL ORIENTATION DOESN'T REQUIRE PUBLIC APPROVAL, ALINE!

SUSAN WEARS A HIJAB OUT OF CHOICE, BUT MANY SAY SHE IS JUST "ANOTHER WOMAN OPPRESSED BY ISLAM".

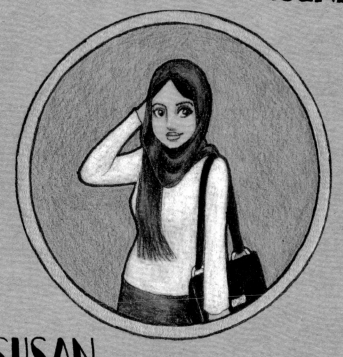

SUSAN, WHAT YOU WEAR IS YOUR OWN PERSONAL DECISION, AND "OPPRESSION" WOULD BE TO STRIP YOU OF THE FREEDOM TO CHOOSE!

FOR SO LONG, BIA HAS HEARD MEN SAY IT'S HARD TO FIND A WOMAN WHO PREFERRED BOOKS TO SHOES.

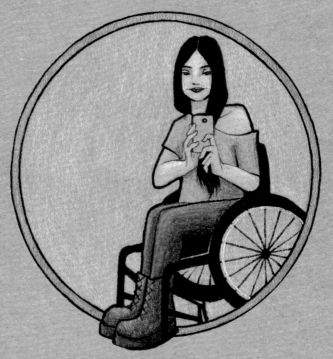

BIA LOVES SHOES AND IS A Ph.D IN FRENCH LITERATURE. SHE NEVER REALLY UNDERSTOOD THE SO-CALLED INCOMPATIBILITY BETWEEN HER PASSIONS.

LARISSA HEARD A THOUSAND TIMES SHE'S NOT A "REAL WOMAN."

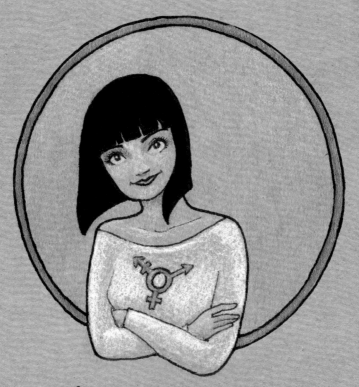

BUT THAT'S EXACTLY WHAT YOU ARE, OK, LARISSA? YOU ARE THE ONLY AUTHORITY ON YOUR BODY AND YOUR IDENTITY!

SARAH IS A TRANS WOMAN AND WAS RECENTLY DISRESPECTED AND MADE TO FEEL ASHAMED BY TWO CIS WOMEN IN A FEMALE PUBLIC TOILET.

SARAH, YOU DESERVE TO BE RESPECTED WHEN USING PUBLIC FACILITIES JUST LIKE ANY OTHER PERSON!

WHEN **CLAUDiA** GAVE **BiRTH,**
SHE WAS TOLD TO HAVE COSMETIC SURGERY
DONE ON HER **iNTERSEX CHiLD.**

CLAUDiA KNOWS THAT'S A DECISION
ONLY HER CHiLD CAN MAKE SOMEDAY
IN THE **FUTURE.**

VANESSA is ASEXUAL.

MOST PEOPLE DON'T GET IT AT ALL AND SAY SHE JUST HASN'T "TRIED IT PROPERLY."

IT'S OK, VANESSA.

YOU DON'T HAVE TO **LOVE** IN A WAY THAT DOESN'T MATCH YOUR **IDENTITY**. **LOVE** DOESN'T HAPPEN THE SAME WAY FOR **EVERYBODY**!

WHEN MAITE HAD HER FIRST GIRLFRIEND AT 16, MANY THOUGHT SHE WAS JUST EXPERIMENTING.

IT MAY AS WELL HAVE BEEN THE CASE, BUT MAITE CAN'T RECALL EVER HEARING THAT HER SISTER WAS SIMPLY GOING THROUGH A PHASE WHEN SHE HAD HER FIRST BOYFRIEND...

NATALIE HAS BEEN TOLD THAT HER STYLE IS NOT APPROPRIATE FOR A WOMAN HER AGE.

NATALIE, YOU ARE FREE TO EXPRESS YOUR IDENTITY THROUGH YOUR BODY AT ANY AGE!

MAYRA HAS BEEN TOLD SHE MUST **CHOOSE** ONCE AND FOR ALL iF SHE'S A **MAN** OR A **WOMAN.**

MAYRA,

NOT EVERYONE NEEDS TO FiT iNTO **BiNARY GENDER** CATEGORiES. YOU DON'T NEED PUBLiC APPROVAL TO LiVE AND EXPRESS YOUR **iDENTiTY!**

BRUNA KRENAK HAS BEEN TOLD THAT SHE SHOULDN'T BE CONSIDERED INDIGENOUS ANYMORE BECAUSE SHE WEARS JEANS AND GOES TO COLLEGE.

BRUNA, YOU ARE THE ONLY PERSON IN THE WORLD WHO CAN DEFINE YOUR OWN IDENTITY, AND NOBODY ELSE HAS ANY RIGHT TO DENY IT FOR YOU!

SAMIRA LOVES HER FAMILY AND WOULD NEVER USE HER CHILDREN AS HUMAN SHIELDS IN A VIOLENT CONFLICT.

YOUR KIDS LOVE YOU TOO, SAMIRA, AND THERE'S ABSOLUTELY NO REASON FOR ANYONE TO ASSUME OTHERWISE.

AGNES IDENTIFIES AS **AROMANTIC** AND SOMETIMES FEELS **BOTHERED** BY PEOPLE SAYING THAT SHE SHOULD "GET A **HUSBAND**."

AGNES, THERE'S **NOTHING** WRONG WITH NOT BEING INTERESTED IN THIS KIND OF **RELATIONSHIP.** YOU CAN LIVE YOUR **IDENTITY** AND YOUR **FEELINGS** IN **YOUR OWN WAY!**

BABI IS SEVEN YEARS OLD.
HER PARENTS FOUND IT A **BIT ODD** THAT
SHE CHOSE TO TAKE **KARATE** INSTEAD OF
BALLET.

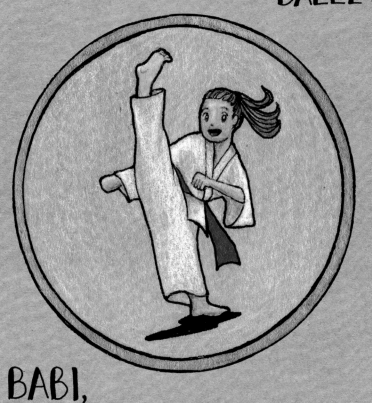

BABI,
GENDER CONVENTIONS SHOULD **NEVER**
LIMIT YOUR **IDENTITY.**
YOU CAN DO
WHATEVER YOU WANT**!**

COLLETTE DOESN'T IDENTIFY WITH SOCIETY'S EXPECTATIONS FOR SENIOR CITIZENS, AND AT THE AGE OF 64, SHE ENROLLED IN COLLEGE TO EARN A DEGREE IN ARCHITECTURE

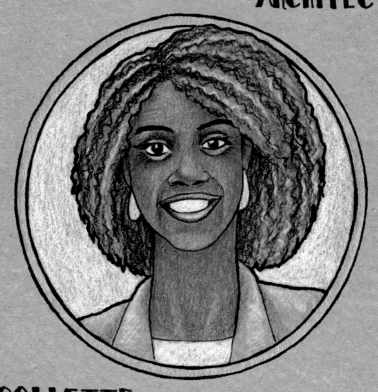

COLLETTE, YOUR WILL TO LEARN AND LOVE FOR LIFE DO NOT DEPEND ON YOUR AGE!

RASHIDA, CRIS & CLEO

PREFER NOT TO TALK ABOUT **FEMINISM** WITH THEIR FAMILIES BECAUSE THEY'VE BEEN TOLD TO THINK ABOUT "MORE IMPORTANT THINGS" INSTEAD.

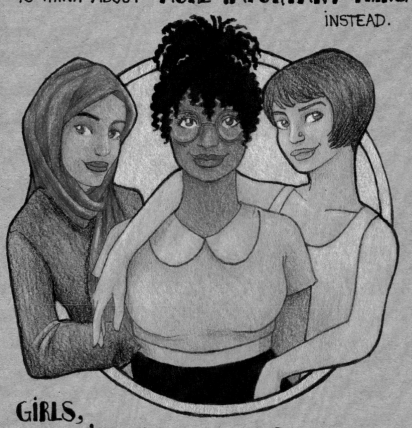

GIRLS, YOUR **FIGHT** FOR A **SAFER** AND MORE **RESPECTFUL** ENVIRONMENT IS DEFINITELY **NOT** A MINOR SUBJECT. **DON'T LET THE HATERS GET YOU DOWN!**

ALICIA HAS INDIGENOUS HERITAGE, BUT THAT'S NOT EVIDENT BECAUSE OF HER **PALE SKIN.** MANY SEEM TO EXPECT THAT SHE **ABANDON** THIS PART OF HER **IDENTITY.**

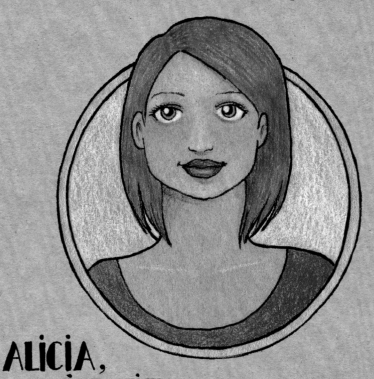

ALICIA, YOUR **IDENTITY** SHOULDN'T BE DENIED BECAUSE OF YOUR APPEARANCE, FOR IT IS MUCH MORE **COMPLEX** THAN SKIN TONE. **YOU** CAN BE PROUD OF YOUR **CULTURAL** HERITAGE EVEN IF YOU DON'T FIT THE OTHERS' **IDEA** OF WHAT IT IS TO **BE INDIGENOUS.**

CAMILLE HAS HEARD THAT SHE SHOULDN'T GO THROUGH **HORMONAL GENDER** TRANSITION SINCE SHE'S ATTRACTED TO **WOMEN.**

CAMILLE, YOUR **GENDER** IDENTITY HAS NOTHING TO DO WITH YOUR **SEXUALITY.** YOU HAVE EVERY RIGHT TO **TRANSITION,** REGARDLESS OF YOUR **SEXUAL ORIENTATION.**

NATASHA IS ATTRACTED TO PEOPLE WITH WHOM SHE FEELS A SPECIAL CONNECTION REGARDLESS OF THEIR GENDER, SO SHE IDENTIFIES AS A PANSEXUAL.

IT'S TRUE THERE'S STILL A LOT OF MISINFORMATION SURROUNDING PANSEXUALITY, BUT THAT'S HOW NATASHA FEELS AND NO ONE SHOULD INVALIDATE HER IDENTITY!

MELISSA CAME **OUT** OF THE CLOSET AT **82** YEARS OLD, AND MANY PEOPLE SAID SHE WAS BEING **SELFISH** NOT THINKING ABOUT HER **GRANDCHILDREN.**

MELISSA, LIVING YOUR **IDENTITY** ISN'T SELFISHNESS; IT'S **SELF-LOVE.** TEACHING YOUR GRANDCHILDREN ABOUT **RESPECT** AND **DIVERSITY** IS A **MUCH BETTER** LESSON THAN **FEAR** AND **INTOLERANCE.**

MICHAELLA HEARD COMMENTS THAT SHE WOULDN'T BE A **GOOD** ROLE MODEL FOR HER KID BECAUSE OF HER **TATTOOS** AND **PIERCINGS.**

MICHAELLA, YOU DON'T **JUDGE** PEOPLE FOR HOW THEY LOOK BASED ON YOUR OWN **IMPRESSIONS,** AND THAT ALREADY MAKES YOU A GREAT ROLE **MODEL** TO YOUR KIDS.

VIRGINIA IS MARRIED TO A **WOMAN** AND BELIEVES IN **GOD**. SHE HEARD, HOWEVER, THAT SHE SHOULDN'T BE **RELIGIOUS** BECAUSE SHE'S **GAY**.

VIRGINIA, YOU CAN **BELIEVE** IN WHATEVER YOU WANT, REGARDLESS OF YOUR **SEXUALITY**. YOUR **FAITH** IN GOD DOESN'T MEAN YOU CAN'T FIGHT FOR MORE **TOLERANCE** AND ACCEPTANCE INSIDE THE **CHURCH**.

SASHA IS A GENTLE AND CREATIVE LIONESS WHO WORKS WITH GRAPHIC DESIGN. SHE HAS BEEN LOOKING FOR A GOOD JOB.

IT'S NOT AN EASY TASK WHEN THE EMPLOYERS ANALYZE HER MANE INSTEAD OF HER PORTFOLIO. BUT DON'T BE DISCOURAGED, SASHA. WHOEVER HIRES YOU WILL SEE HOW GREAT YOU ARE!

Choices

We all have to make choices in our lives. Some are little, everyday things, and some are big things that define our future, such as career, marriage, family, etc. For women, there's a strong societal control over this autonomy. We're heavily judged when we choose a different path than the one expected by society.

Some people ask me why I don't portray a lot of women with conservative views. There are thousands of different women and stories, and I'm not pretentious to think I'm able to represent them all. So I chose to present issues that are hardly ever openly discussed for being marginalized. I believe it's not feminism's role to criticize women's choices, as long as they're deliberately made and don't limit others' freedoms.

Of course, we often reproduce oppressive actions because of the concepts we've been introduced to since birth, and it's important to get to know other ideas and deconstruct certain biases. However, I don't think we should ever assume that's the case for all people (including women) who defend conservative views. I don't agree with the idea that a woman can either be a "badass feminist" (the stereotype of the independent woman) or a "victim of patriarchy" (the stereotype of the woman who can't think for herself), depending on her choices. Reducing women to "victims of the patriarchy" whenever they make decisions or expose ideas to which we don't agree is ignoring the conscience and responsibility of each one. And maybe that's just another way of judging women for their personal choices. We should all feel free to make our own choices, and they're not only valid when others agree with us.

ALICE IS INTO CASUAL SEX.

SOME FRIENDS, HOWEVER, TELL HER TO "RESPECT HERSELF" BY CHANGING HER BEHAVIOR.

ALICE KNOWS HER SEX LIFE HAS NOTHING TO DO WITH HER RESPECT.

CECILIA LOVES POLE DANCE,

BUT SHE'S BEEN TOLD TO STOP PRACTICING IT OTHERWISE PEOPLE WOULD "START TALKING".

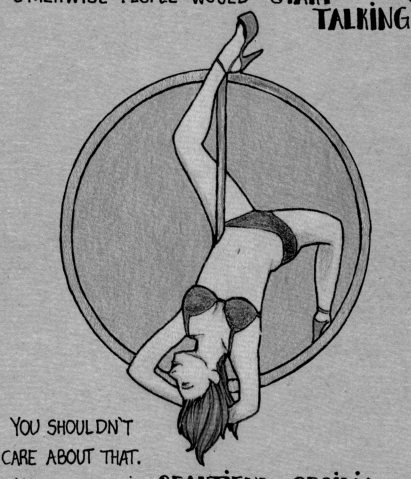

YOU SHOULDN'T CARE ABOUT THAT. YOUR DANCE IS **BEAUTIFUL, CECILIA,** AND THERE'S **NOTHING** WRONG WITH IT! YOU CAN EXERCISE HOWEVER YOU LIKE—IT WILL ONLY DO YOU *GOOD!*

CLARA is an ENGINEER who is DONE HEARING THAT WOMEN AND MATHEMATICS DON'T "GO TOGETHER".

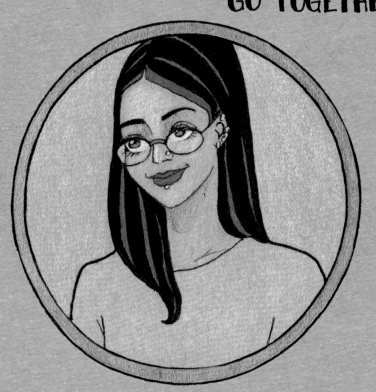

RELAX, CLARA. THOSE WHO THINK THAT GENDER DETERMINES INTELLECTUAL PERFORMANCE CAN'T POSSIBLY HAVE GOOD LOGIC.

DESPITE BEING PRESSURED TO HAVE A C-SECTION, FERNANDA DECIDED TO GIVE BIRTH NATURALLY.

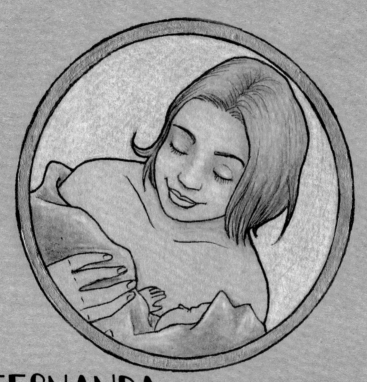

FERNANDA, THIS IS A PERSONAL CHOICE. NEITHER OPTION MAKES YOU LESS OF A WOMAN OR A MOTHER.

ISAURA HAD AN ABORTION.

EVERYBODY SEEMED A LOT MORE WILLING TO **JUDGE** THE **LEGITIMACY** OF HER REASONS THAN ACTUALLY **HELP HER.**

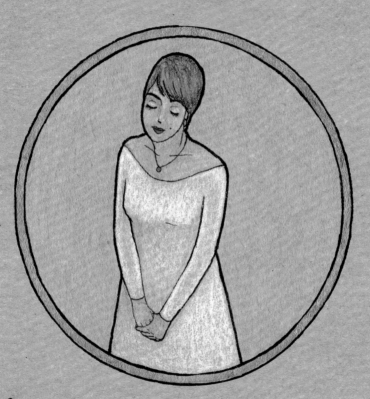

ISAURA,
REGARDLESS OF YOUR REASONS, YOU **DESERVED** A **SAFE PROCEDURE.**

LAÍS AND PAULA ARE BEST FRIENDS AND ALWAYS MEET TO CATCH UP.

LAÍS is a PORN STAR AND PAULA is a HOUSEWIFE. ONE HAS ALWAYS SUPPORTED THE OTHER'S CHOICES — WHICH IS FANTASTIC, BECAUSE THE REST OF THE WORLD ONLY CRITICIZED. GIRLS, YOU CAN BE WHATEVER YOU WANT.

WHEN **MONICA** HAD HER FIRST CHILD AT **17**, SOME PEOPLE SAID: "POOR GIRL... RUINING HER LIFE NOW! I NOTICED BEFORE SHE WAS A BIT OF A SLUT..."

MONICA NEVER SAW HERSELF AS A **VICTIM** OR A **SLUT**, AND SHE THINKS HER DAUGHTER IS THE **BEST THING** THAT HAS EVER HAPPENED TO HER!

ROSE DECIDED NOT TO HAVE KIDS.

NO WORRIES, ROSE. MOTHERHOOD IS A CHOICE, AND YOUR DECISION DOES NOT MAKE YOU ANY LESS OF A WOMAN!

RENATA LOVES FOOTBALL BUT OCCASIONALLY HEARS THAT IT IS NOT A "SPORT FOR WOMEN."

RENATA, DON'T PAY THEM ANY ATTENTION. GO AHEAD AND CHEER YOUR TEAM ON!

RACHEL HAS FELT PRESSURED TO HAVE SEX EVEN WHEN SHE DIDN'T FEEL LIKE DOING IT.

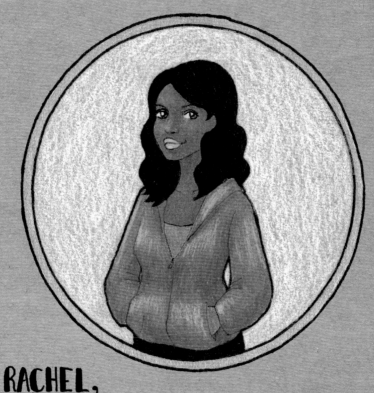

RACHEL, YOUR BODY IS ONLY YOURS, AND NOBODY HAS THE RIGHT TO ENJOY IT WITHOUT YOUR CONSENT. HAVE SEX WHEN, WHERE, WITH WHOM, AND IF YOU WANT!

LILY DOESN'T FEEL GOOD ABOUT EATING **ANIMALS**, BUT MANY PEOPLE SEEM TO BOTHER HER ABOUT HER **EATING HABITS.**

LILY, NOBODY HAS ANYTHING TO DO WITH WHAT **YOU EAT** OR CHOOSE **NOT** TO **EAT.** YOUR **NUTRITION** ONLY CONCERNS **YOU!**

LOLA HAS BEEN TAKING **BIRTH CONTROL PILLS** FOR SOME TIME NOW AND WAS **SURPRISED** WHEN SOMEONE TOLD HER IT'S NOT "SOMETHING **GOOD GIRLS DO**."

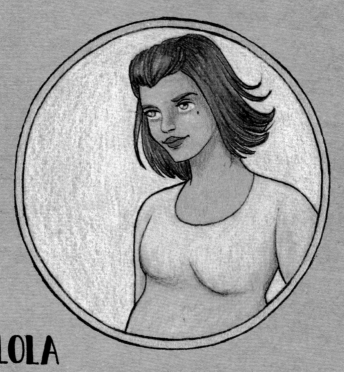

LOLA DOESN'T THINK THERE'S ANYTHING **WRONG** WITH **ENJOYING SEX** AND AVOIDING **PREGNANCY.** YOU'RE RIGHT, **LOLA.** AFTER ALL, IT'S **YOUR BODY!**

WENDY DECIDED NOT TO GIVE UP HER LAST NAME WHEN SHE GOT MARRIED.

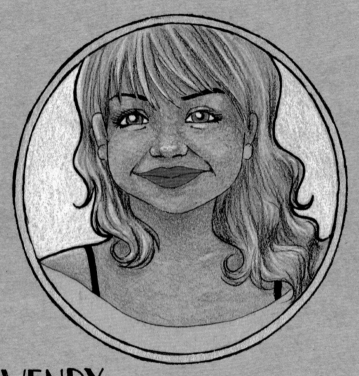

WENDY KNOWS THAT LOVE DOESN'T DEMAND ANYONE TO GIVE UP SYMBOLS OF THEIR OWN IDENTITY IN ITS NAME. IF YOUR NAME IS IMPORTANT TO YOU, YOU SHOULD KEEP IT!

WHEN NADIA DECIDED NOT TO BAPTIZE HER SON VICTOR, MANY SAID THAT IT WOULD ONLY BRING HIM SUFFERING.

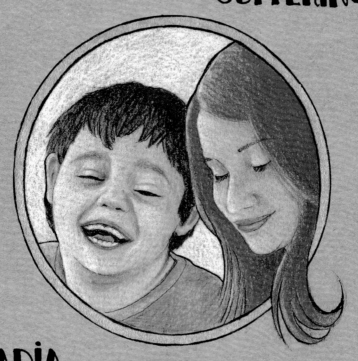

NADIA, HAPPINESS IS NOT A PRIVILEGE HELD ONLY FOR CHRISTIANS, AND YOU DON'T NEED RELIGION TO TEACH IMPORTANT VALUES TO YOUR KID!

SOME PEOPLE SAID THAT **THAIS** SHOULD **GIVE UP** HER **DREAM** BECAUSE SOME JOBS ARE REALLY MEANT "**JUST,** FOR **MEN.**"

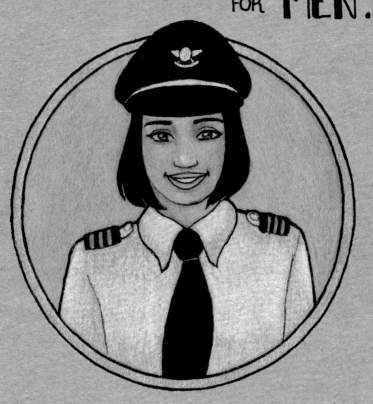

THAIS WAS THE FIRST **WOMAN** IN HER TOWN TO BECOME AN **AIRPLANE PILOT** AND DOESN'T REGRET IGNORING THE **BAD ADVICE!**

SUKI HAS BEEN CALLED A "FAKE GAMER GIRL" FOR LIKING VIDEOGAMES.

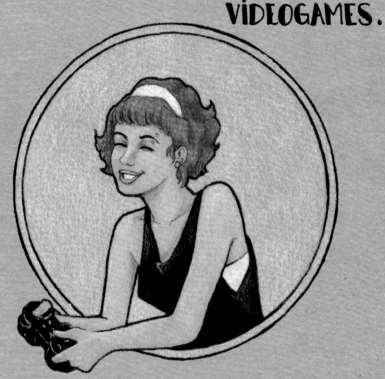

DESPITE THE **PROTESTS** OF ANGRY FANBOYS WHO SAY "**WOMEN** ONLY PLAY **GAMES** FOR ATTENTION", AND DESPITE THE **SEXIST** MARKETING MANY VIDEOGAME DEVELOPERS STILL SHOW, **SUKI** KNOWS THE **GAMING** WORLD ISN'T JUST FOR **MEN**, AND SHE WON'T STOP DOING WHAT SHE LOVES BECAUSE OF **SEXISM**.

MYRIAM CHOSE TO ADOPT A DAUGHTER EVEN THOUGH SHE WASN'T INFERTILE, AND SOME PEOPLE CRITICIZED HER DECISION.

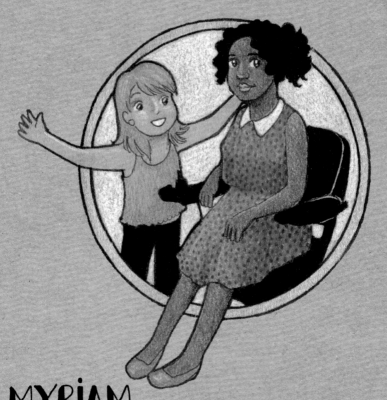

MYRIAM, YOUR DAUGHTER WAS NOT CONCEIVED IN YOUR UTERUS, BUT IN YOUR HEART. IT DOESN'T MAKE YOU ANY LESS OF A MOM, AND YOUR LOVE FOR YOUR CHILD SHOULDN'T BE UNDERESTIMATED!

KATJA HAS BEEN CRITICIZED FOR BREASTFEEDING IN PUBLIC.

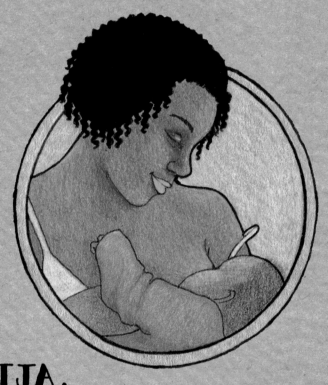

KATJA,
YOU DON'T HAVE TO REMAIN **HOME** DURING THE **WHOLE** BREASTFEEDING PERIOD OF YOUR **CHILD**, THERE'S **NOTHING** OBSCENE ABOUT DOING THIS IN PUBLIC. THE **FEMALE BODY** SHOULDN'T BE CONSTANTLY **SEXUALIZED**.

WHEN **AMELIA** GOT **DIVORCED,**
MANY PEOPLE **JUDGED** HER AS **SELFISH,**
SAYING SHE WASN'T THINKING OF WHAT WAS
BEST FOR HER **KIDS.**

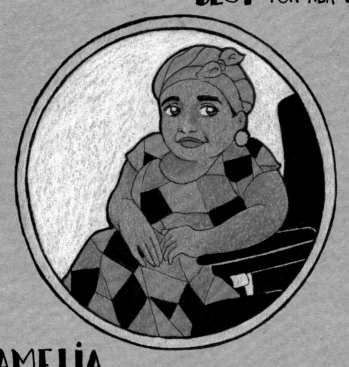

AMELIA,
INSISTING ON A **BAD** RELATIONSHIP ISN'T
HEALTHY TO **ANYONE** IN THE FAMILY,
ESPECIALLY **YOU.** YOUR **DIVORCE** IS NOT
ABOUT SELFISHNESS. IT'S ABOUT SELF-ESTEEM
AND **STRENGTH** TO **START OVER!**

SAMIE ALWAYS WANTED TO BE AN ARTIST, BUT HER FAMILY USED TO DISCOURAGE HER, SAYING SHE WOULD **NEVER** EARN ENOUGH TO **GET BY.**

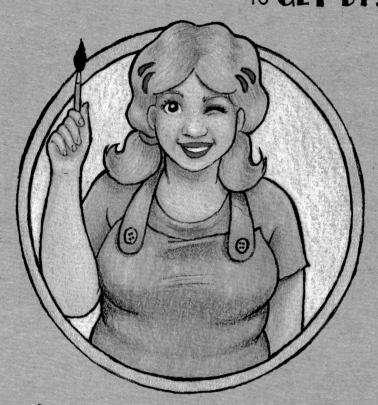

SAMIE, NOBODY SHOULD TRY TO MAKE YOU GIVE UP YOUR **DREAMS**. YOU MAY EARN A **TON** OF MONEY, BUT LIVING A ROUTINE DOING WHAT YOU **DON'T LIKE** DOESN'T GUARANTEE **HIGH LIFE QUALITY.**

CHLOE HAS BEEN PICKED ON FOR BEING A VIRGIN AT THE AGE OF 22.

CHLOE,
YOU SHOULD HAVE **SEX** WHEN AND **IF** YOU WANT. **RESPECT YOUR BODY, YOUR RHYTHM,** AND **YOUR WILL.** AND NOBODY HAS ANYTHING TO DO WITH THAT!

JULIET BELIEVES IT'S IMPORTANT TO TALK ABOUT **FEMALE** MASTURBATION WITHOUT **TABOOS**, BUT MANY THINK IT'S NOT A **PROPER** SUBJECT TO DISCUSS IN **PUBLIC**.

JULIET,
IT'S VERY IMPORTANT TO ENCOURAGE **GIRLS** TO **KNOW** THEIR BODIES AND UNDERSTAND THEIR **PLEASURE** AS WELL AS BOYS, AND TALKING **NATURALLY** ABOUT IT IS THE FIRST STEP!

ABBY IS A STRIPPER, AND SOME SAID THAT SHE SHOULD HAVE STOPPED WHEN SHE BECAME A MOTHER.

ABBY'S SON IS 6 YEARS OLD NOW AND NEVER HAD A PROBLEM BECAUSE OF HIS MOM'S JOB. SHE TAUGHT HIM TO DO WHAT HE LIKES DESPITE PEOPLE'S PREJUDICES.

WHEN **GRACE** SAID FOR THE FIRST TIME THAT SHE WANTED TO BE IN THE MILITARY, SOME SAID THAT "IT WAS NO JOB FOR A **LADY.**"

NOWADAYS, **GRACE** IS A **COMMANDER** WHO LOVES HER **JOB.** THAT'S RIGHT, **GRACE,** DON'T LET ANYONE ELSE DEFINE YOUR **DREAMS.**

NICOLE DECIDED TO BE A BOOKSELLER BECAUSE SHE LOVES LITERATURE AND THINKS IT'S IMPORTANT TO SPREAD KNOWLEDGE.

NICOLE, I CAN'T THINK OF A GREATER JOY THAN PROMOTING LITERATURE IN A JOB YOU LOVE — AND THAT'S EXACTLY WHAT YOU DO!

Love

Whatever kind of love is worthy.
Whatever kind of love is worth loving.
("Paula e Bebeto," by Milton Nascimento)

Apparently, anything in the world can be censored if it breaks traditional expectations, including love. For a long time, we have seen practically a single representation of a loving, romantic relationship: that is, involving one man and one woman who are young, white, cisgender, heterosexual, and Christians. There is nothing wrong with this model, but that's not the only one out there.

Representation in the media is what creates our notion of what is normal and what is not. This representation is so centered on that classic couple that many other kinds of romantic love cause great discomfort for people.

I believe this representation of romance in movies, books, TV shows, and advertisements still needs to be improved. It must get wider and naturalize what is, indeed, natural. Love should be celebrated in all its forms. I pose a simple question with these illustrations: why do certain kinds of consensual, loving relationships bother so many people?

ANNE LOVES HER GIRLFRIEND, JULIA, BUT SHE HASN'T GATHERED THE COURAGE TO INTRODUCE HER TO HER PARENTS, AS SHE KNOWS THEY WOULDN'T ACCEPT IT.

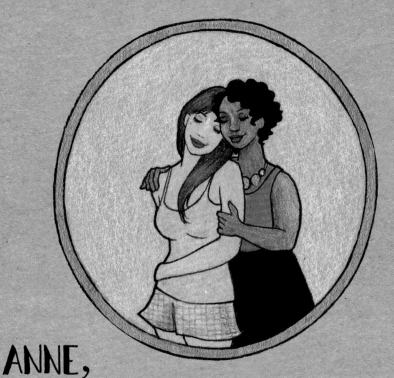

ANNE, IT'S A SHAME SOME PEOPLE ARE STILL NOT CAPABLE OF TREASURING LOVE IN ALL OF ITS FORMS. BUT DON'T YOU WORRY — IT WILL GET BETTER!

BELA LUCAS & LEO HAVE BEEN DATING FOR SOME TIME NOW AND THEY'RE REALLY **HAPPY TOGETHER!**

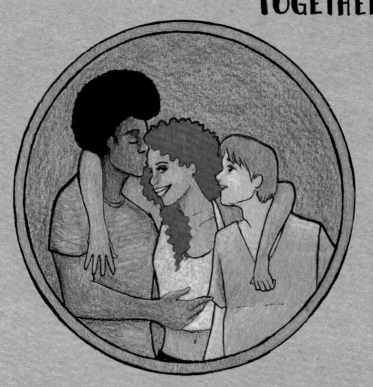

NOT EVERYONE APPROVES, BUT **BELA** THINKS IT'S **SILLY** THAT SOMEONE SHOULD INTERFERE IN A **CONSENSUAL** RELATIONSHIP IN WHICH EVERYBODY IS **HAPPY.** I AGREE, BELA.

LUMA AND DANIEL DON'T UNDERSTAND WHY THE COLOR OF THEIR SKIN WOULD BE A BARRIER TO THEIR RELATIONSHIP.

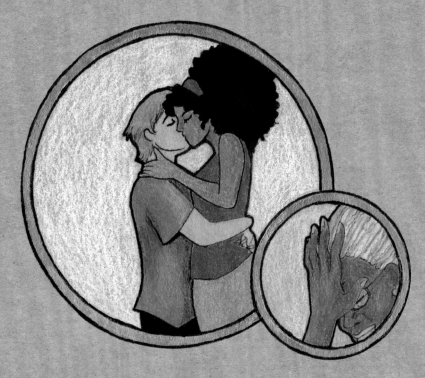

AND HER GRANDMOTHER WAS REALLY UPSET WHEN SHE FOUND OUT THAT LUMA HEARS TODAY THE SAME KIND OF COMMENTS SHE HEARD HERSELF WHEN SHE DATED A WHITE BOY BACK IN 1948!

MANU HAS DWARFISM AND HAS HEARD PLENTY OF **MEAN COMMENTS,** ESPECIALLY WHEN SHE'S OUT WITH HER BOYFRIEND (WHOSE HEIGHT IS AVERAGE).

MANU, YOU'RE ENTITLED TO **LOVE** LIKE **ANYONE ELSE!** DON'T YOU CARE ABOUT THESE FOLKS, OK? **BE HAPPY** WITH YOUR LOVE AND YOUR **BODY!**

RITA IS 19 YEARS OLDER THAN DIEGO AND OFTEN HEARS THAT SHE SHOULD FIND SOMEONE HER OWN AGE.

RITA THINKS THOSE AROUND HER WOULD BE HAPPIER IF THEY MINDED THEIR OWN BUSINESS INSTEAD OF HER RELATIONSHIP — WHICH HAS BEEN GOING WELL FOR 4 YEARS, THANKS FOR ASKING!

NAYANA ONCE HEARD THAT A COUPLE IS "UGLY" IF THE WOMAN IS TALLER THAN THE MAN.

NAYANA AND ROB ARE VERY HAPPY TOGETHER AND CAN'T UNDERSTAND HOW ANYONE CAN THINK OF LOVE AS AN UGLY THING!

DIANA AND LUCAS HAVE CHOSEN TO LIVE **TOGETHER** WITHOUT BEING OFFICIALLY **MARRIED.**

INVOLVING **RELIGION** AND **BUREAUCRACY** IN YOUR RELATIONSHIP IS A **CHOICE,** AND NOT INVOLVING THEM DOESN'T MAKE YOUR **LOVE** ANY LESS **LEGITIMATE.**

EMILLY MEL IS A TRANS WOMAN AND HAS HER **IDENTITY** DISRESPECTED EVERY TIME SOMEONE ASKS IF HER BOYFRIEND **WILLIAN** is GAY.

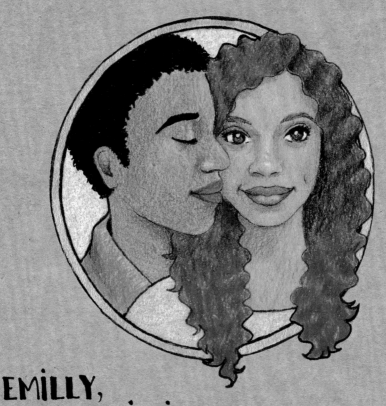

EMILLY, YOU AND **WILLIAN** ARE A BEAUTIFUL **HETEROSEXUAL** COUPLE, AND YOUR **LOVE** IS A LOT MORE IMPORTANT THAN THE **OPINION** OF OTHERS.

MANY PEOPLE HAVE iNSiNUATED THAT
LiNDA is ONLY DATiNG ALERiA
OUT OF PiTY BECAUSE OF THE DiFFERENCE
BETWEEN THEiR BODiES.

BUT ALERiA & LiNDA
LOVE EACH OTHER VERY MUCH,
AND THEY HAVE LEARNED TO iGNORE THE
MEAN COMMENTS THEY HEAR.

CHIARA AND SUZI KNOW WELL THE **CHALLENGES** OF A **LONG DISTANCE** RELATIONSHIP. STILL, MANY PEOPLE SEEM TO BE EAGER TO **CONSTANTLY** REMIND THEM.

IF THE **LOVE** THAT UNITES YOU IS **GREATER** THAN THE **DISTANCE** THAT KEEPS YOU APART, THE CHALLENGES WON'T BE A PROBLEM — TO THE **VULTURES'** DESPAIR!

CARMEN AND PHIL MET WHEN THEY WERE REALLY YOUNG AND DECIDED TO GET MARRIED WHEN THEY WERE BOTH 19. MANY SAID THEY WERE TOO YOUNG AND SHOULD "LIVE THEIR LIVES" BEFORE GETTING MARRIED.

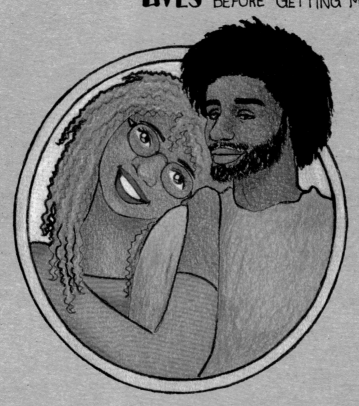

THEY'RE "LIVING THEIR LIVES" TOGETHER VERY HAPPILY, THANK YOU VERY MUCH, AND NEVER SAW THEIR MARRIAGE AS A LIMITATION TO THEIR FREEDOM AND HAPPINESS!

JANINE REALIZED WHEN SHE WAS YOUNG THAT SHE WOULDN'T ADAPT TO MONOGAMIST RELATIONS, AND THEREFORE ONLY ENGAGES IN OPEN RELATIONSHIPS. SOME SAY HER LIFESTYE IS IMMORAL.

JANINE, YOU ARE HONEST WITH YOURSELF, HAPPY WITH YOUR CHOICES, AND RESPECTFUL TO YOUR PARTNERS WHEN YOU TALK STRAIGHT ABOUT YOUR WAY TO LOVE. THE ONLY IMMORALITY IS THE PREJUDICE THAT SURROUNDS YOU.

FLÁVIA ALWAYS HAD MANY **MALE FRIENDS** AND GETS UPSET WHEN SHE HEARS "THERE'S NO **SUCH THING**" AS A **REAL** FRIENDSHIP BETWEEN A **MAN** AND A **WOMAN**.

FLÁVIA, IF THE PERSON WHO SAID THAT DOESN'T HAVE ANY **REAL FRIENDS** OF ANOTHER GENDER, IT'S LIKELY THAT THEY'RE **NO GOOD COMPANY** TO **ANYONE!**

ERICA AND LILIAN ARE TIRED OF HEARING THAT WOMEN ARE "WAY TOO COMPETITIVE", AND REAL FRIENDSHIP IS SOMETHING THAT ONLY EXISTS AMONG MEN.

THEY HAVE BEEN FRIENDS FOR A LONG TIME AND DON'T KNOW WHERE THIS ABSURD IDEA CAME FROM. WOMEN ARE GREAT FRIENDS, AND THE SORORITY FEELING SHOULDN'T BE UNDERESTIMATED.

WHEN **NORA** WAS GOING OUT WITH **PETER**, SOME PEOPLE SAID THAT SHE WAS **ONLY INTERESTED** IN HIS **MONEY.**

NORA IS WITH **PETER** BECAUSE SHE **LOVES** HIM AND HATES THIS KIND OF ACCUSATION. IT'S ABSURD THAT PEOPLE **JUDGE** OTHERS NOT KNOWING THE FIRST THING ABOUT THEM. IT ONLY REINFORCES **RIDICULOUS** GENDER STEREOTYPES**!**

Brave

At the start of this project, I questioned if I should approach more polemical themes. I soon realized that it was extremely important to discuss violence and the challenge of dealing with traumas, diseases, or any other issues that require from us more courage to get through the end of the day. Also, I noticed that some themes that were really easy for me turned out to be unexpectedly controversial to other people. Anyway, whatever the case may be, it's not unusual that some people still don't find the support they deserve among their beloved ones.

Most issues here reveal a serious societal problem. People still blame victims for their attacks, and that should never happen. Another interesting point of discussion is the freedom of each one to deal with their issues in their own ways, respecting their own rhythms.

Finally, I think the message behind all of these illustrations is that we should take care not to judge people without knowing them. We're all fighting our own battles and it is important to respect the fact that there's a lot more to people than what meets the eye.

ANA WAS RAPED.

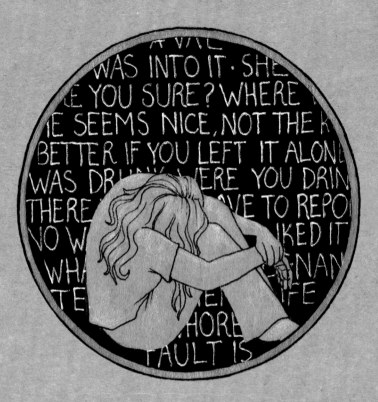

ANA, YOU ARE NOT ALONE.
IT'S NOT YOUR FAULT.

THIS EXPERIENCE IS NOT WHAT DEFINES YOU AS A
HUMAN BEING. YOU ARE SO MUCH MORE THAN THIS.

AS A CHILD, **GISELLE** WAS SEXUALLY ABUSED BY A FAMILY "FRIEND", AND MANY BELIEVED SHE WOULD NEVER BE **HAPPY** AGAIN.

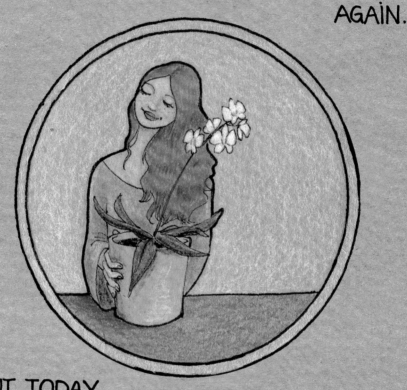

BUT TODAY, **GISELLE** IS VERY HAPPY. SHE WAS HURT, BUT NOT BROKEN. SHE IS **MUCH MORE** THAN WHAT SOMEONE DID TO HER.

REBECCA HAD **DEPRESSION,** AND ONLY AFTER MANY MONTHS SHE WAS ABLE TO WEAR CLOTHES THAT REVEALED THE **SCARS** LEFT ON HER **BODY.**

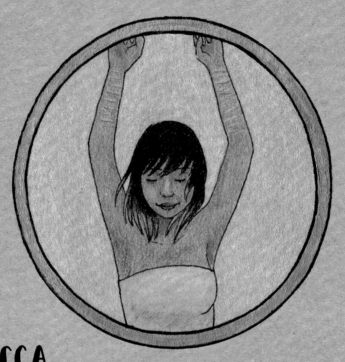

REBECCA,

THESE MARKS ARE A REMINDER OF HOW **BRAVE** YOU HAVE HAD TO BE! PSYCHOLOGICAL PAIN IS ALSO **HUMAN,** AND SUFFERING IT DOES NOT MAKE YOU **ANY LESS** OF A **PERSON.**

ELISA'S BOYFRIEND KEPT TELLING HER SHE COULD NEVER **LEAVE** HIM BECAUSE NOBODY ELSE WOULD EVER LOVE AN "INCOMPLETE WOMAN."

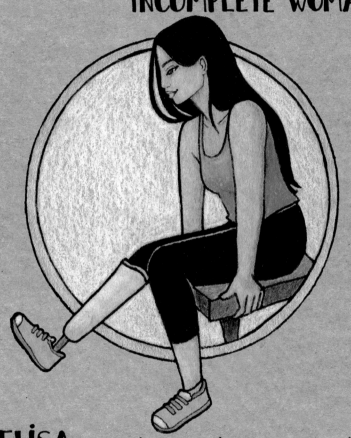

ELISA DOESN'T FEEL INCOMPLETE SINCE HER **INNER LOVE** AND HER FRIENDS' **SUPPORT** GAVE HER THE **STRENGTH** TO LET GO OF AN **ABUSIVE** RELATIONSHIP!

TEJASWINI HAD HER INTIMACY DISRESPECTED WHEN HER INTIMATE PICTURES WERE LEAKED ON THE INTERNET.

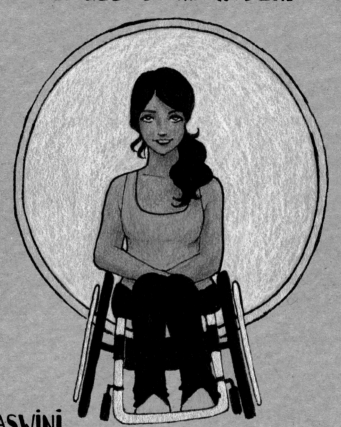

TEJASWINI,
YOU DIDN'T DO ANYTHING WRONG. THE **SHAME** SHOULD BE WITH THE ONE WHO PURPOSELY DECIDED TO CAUSE YOU **PAIN** AND **EMBARRASSMENT** BY EXPOSING YOUR **PRIVACY** WITHOUT **CONSENT**.

SOME PEOPLE DOUBTED THAT **VICKY** HAD BEEN **ABUSED**, SAYING THAT SHE DIDN'T LOOK "**TRAUMATIZED ENOUGH?**"

VICKY,
NOBODY HAS THE RIGHT TO **DICTATE** THE WAY YOU DEAL WITH YOUR OWN EXPERIENCES, AND EVEN LESS TO **JUDGE** THE **WEIGHT** OF THOSE EXPERIENCES BASED ON YOUR **BRAVE SMILE.**

YASMIN SUFFERS FROM **BULIMIA,** BUT MANY DON'T TAKE IT SERIOUSLY BECAUSE HER **BODY** DOESN'T MATCH THE **IMAGE** SOME PEOPLE HAVE OF WOMEN WITH **EATING DISORDERS.**

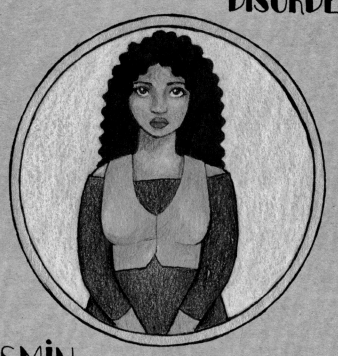

YASMIN, THE FACT THAT YOUR **BONES** ARE NOT SHOWING DOESN'T MEAN YOUR **PROBLEM** SHOULD BE IGNORED. **YOU DESERVE HELP** REGARDLESS OF HOW PEOPLE **THINK** YOU SHOULD **LOOK.**

BRENDA IS ALWAYS GETTING **HARASSED** ON THE STREET WHILE WALKING TO **WORK**.

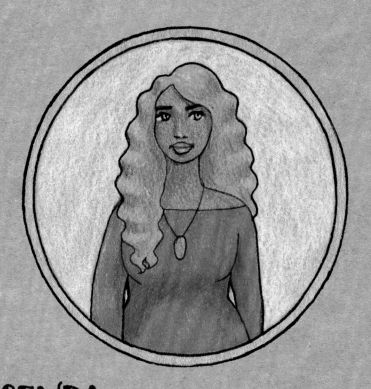

BRENDA, YOU SHOULD **NEVER** HAVE TO FEEL THREATENED WHEN USING **PUBLIC** SPACES LIKE EVERYONE ELSE!

WHEN **LOUISE** FOUND OUT SHE WAS **HIV⁺**, MANY PEOPLE SAID HER **LIFE** WAS **OVER.**

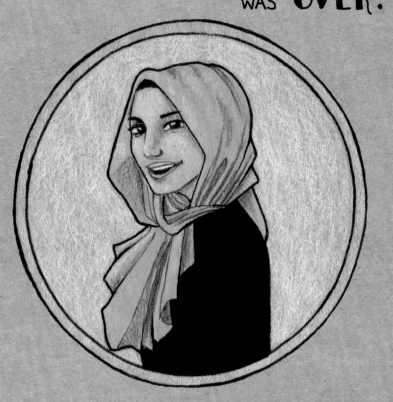

IT'S BEEN SOME TIME NOW SINCE SHE WAS **DIAGNOSED** AND SHE'S LEARNED THAT IT'S POSSIBLE TO BE **HAPPY** AND **LIVE WELL** WITH THE VIRUS, THAT HER **LIFE** IS **MORE** THAN JUST **SURVIVING!**

SOPHIA KNOWS THAT SOME PEOPLE AVOID HER ONCE THEY LEARN SHE'S HIV⁺.

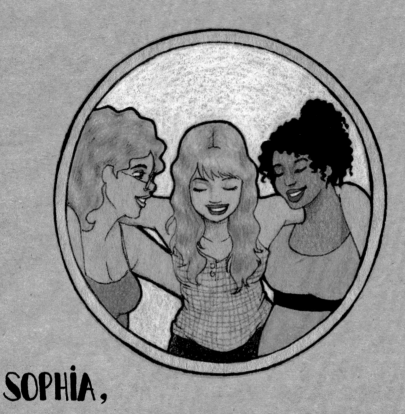

SOPHIA,

YOU SHOULDN'T HAVE TO GO THROUGH SO MUCH **PREJUDICE**. IT'S A GOOD THING THAT YOU'RE ALSO SURROUNDED BY PEOPLE WHO **LOVE** YOU, AND WHO **JOIN** YOU IN FIGHTING MISINFORMATION SURROUNDING **HIV.**

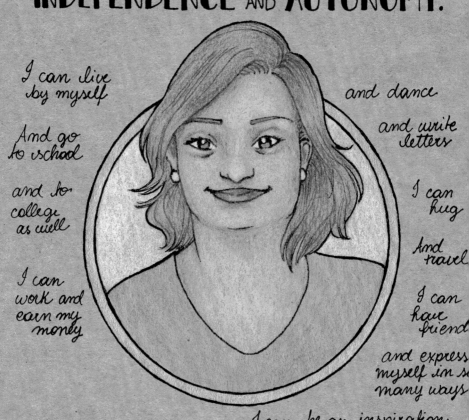

BETTE HAS AN **INVISIBLE CHRONIC ILLNESS,** AND SOMETIMES PEOPLE ARE NOT VERY UNDERSTANDING ABOUT IT BECAUSE SHE ALWAYS **APPEARS** TO BE **HEALTHY.**

BETTE, THERE'S A LOT **MORE** IN YOU THAN WHAT **MEETS THE EYE,** AND YOUR CONDITION SHOULD **NOT** BE UNDERESTIMATED BECAUSE OF THE WAY **YOU LOOK!**

MANY PEOPLE ASK **MARIE** ABOUT HER **GENITALS** WHEN THEY LEARN SHE'S A **TRANS WOMAN.**

MARIE, YOUR BODY IS YOUR BUSINESS **ONLY,** AND WHOEVER ASKS YOU ABOUT IT SHOULD **WIN** THE PRIZE OF **MOST INCONSIDERATE PERSON** OF THE **YEAR.**

WHEN **TINA** REPORTED HER **TEACHER** FOR **HARASSMENT**, SHE WAS ASKED IF SHE REALLY WANTED TO GO ON WITH IT BECAUSE IT WOULD BE **VERY BAD** FOR HIS **FAMILY**.

TINA DIDN'T SEE HOW **HARASSING** STUDENTS AND GOING UNPUNISHED WOULD BE GOOD FOR HIS FAMILY, SO SHE WENT ON WITH HER COMPLAINT DESPITE THE UNIVERSITY'S **LACK** OF **SUPPORT**.

WHEN **MARGOT** TOLD HER FRIENDS ABOUT THE **RAPE** ATTEMPT SHE SUFFERED AT A **PARTY,** SOME OF THEM SAID SHE WAS "**ASKING** FOR IT" BECAUSE OF HER CLOTHES.

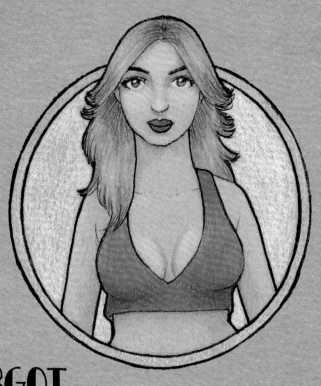

MARGOT, YOU CAN WEAR **WHATEVER** YOU LIKE AND THAT DOESN'T GIVE **ANYONE** THE RIGHT TO **TOUCH** YOUR BODY WITHOUT YOUR **CONSENT!**

ONCE, A STRANGER ASKED **RAFAELA:**
"YOU'RE SO **EXOTIC,**
WHAT ARE YOU?"

RAFAELA PREFERRED TO ANSWER WITH **HUMOR,** SO SHE SAID SHE WAS THE **LAST** LIVING **T-REX,** BUT NOBODY ELSE HAD NOTICED UNTIL THEN, SO HE DESERVED THE PRIZE OF **EXCEPTIONAL PERCEPTION!**

WHEN **ELEONORA** LOST HER **BABY** AT **14** WEEKS OF PREGNANCY, SOME PEOPLE SAID SHE SHOULDN'T BE **SAD** — AFTER ALL, THE BABY "WASN'T EVEN FULLY FORMED" AND SHE COULD **TRY AGAIN.**

ELEONORA, YOU HAVE EVERY RIGHT TO **TAKE YOUR TIME** TO GRIEVE.

WHEN THE **TUMOR** IN **CELESTE'S** BREAST WAS IDENTIFIED, SHE CHOSE TO HAVE A **MASTECTOMY** AND PREVENT THE DEVELOPMENT OF **CANCER.**

SHE DOESN'T FEEL LESS OF A **WOMAN** BECAUSE OF THAT AND HAS **NEVER** REGRETTED HER DECISION. **CELESTE,** MAY **MORE** WOMEN HAVE YOUR **COURAGE** AND **STRENGTH!**

ADA RAN AWAY FROM HOME WHEN SHE WAS 12 TO AVOID **GENITAL MUTILATION** AND IS NOW AN **ACTIVIST** AGAINST THIS KIND OF **VIOLENCE.**

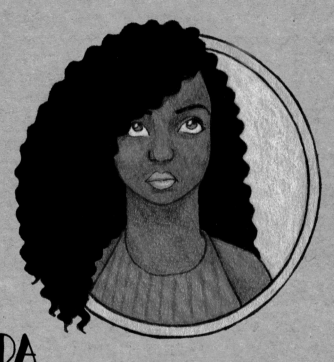

ADA, THIS IS A **SERIOUS ISSUE** THAT STILL AFFECTS HUNDREDS OF **YOUNG GIRLS** IN THE WORLD. **YOU** ARE NOT ALONE IN THE FIGHT FOR **HUMAN RIGHTS** TO **ALL WOMEN!**

ARLETTE HAS NYMPHOMANIA AND REALIZED THAT MOST PEOPLE STILL HAVE AN INCORRECT STEREOTYPICAL IDEA ABOUT HER CONDITION.

ARLETTE,

NYMPHOMANIA CAN BE VERY DISTRESSFUL, BUT YOU'RE NOT THE ONLY ONE GOING THROUGH THIS DAILY CHALLENGE. LIKE ANY OTHER DISEASE, IT IS NOT WHAT DEFINES YOU AS A PERSON!

MANY PEOPLE HAVE CONGRATULATED **THERESA** FOR **LOSING WEIGHT,** NOT REALIZING SHE HAD **ANOREXIA.**

THERESA HAS RECOVERED AND KNOWS **NEVER** TO COMPLIMENT ANYONE SHE DOESN'T KNOW WELL FOR LOSING WEIGHT, BECAUSE SHE KNOWS HOW **DAMAGING** IT MIGHT BE.

YUMI WENT THROUGH A TOUGH TIME BECAUSE OF HER ADDICTION, AND MOST PEOPLE DIDN'T UNDERSTAND THAT A SIMPLE DECISION TO "JUST STOP" WOULDN'T SOLVE HER PROBLEM.

IT TOOK YUMI A LOT OF STRENGTH AND COURAGE WHEN SHE WAS IN REHAB, AND SHE HAS NOW BEEN CLEAN FOR THE PAST 4 YEARS! YOU DID GREAT, YUMI!

Acknowledgments

Since the very beginning, *WOMEN* has been a very special project, and I have tried to do my best. The illustrations are not only drawings; there is even more work behind each of them. All themes were deeply researched so that they would be accurate and sensitive. All texts were written very carefully, thinking twice about every word to keep a clear message. Every drawing was scanned and treated to best preserve the original colors. The texts are all hand-written, and there was a whole process to put image and text together to make it look unique. All illustrations have been revised over and over again to make sure everything is the way it's supposed to be. This project would never have developed the way it did if it weren't for some very special people, and I want to thank them all for working with me and making it happen.

Thank you, Gabriel Nascimento (Shooba), for being who you are: my greatest inspiration. I've grown so much since we met and I can't see how this project could have happened if it weren't for our endless talks about gender and identity. Also, thank you for painting the golden circles around the characters. I'm terribly clumsy with a brush.

Thank you, Barbara Grossi (Babi), for helping me so much with all the files and for being this amazing friend who goes into the dark side of Netflix with me. Yes, we will watch the next episode, until there's no more. Then, we'll just choose another thing to watch. Best afternoons ever.

Thank you, Monica Odom, for reaching out to me and believing in this project. You were supposed to be my literary agent, and now you're also my events manager, text reviser, business consultant, and friend. We've come a long way in a short time, and I'm really happy to have you by my side. Thank you for everything.

Thank you, Renato Novaes (Kid), for working so hard with final artwork. The posters would never look so great if it weren't for you. You're the best!

Thank you, Rodrigo Cerqueira, for being so nice and patient. If it weren't for your perfectionism, the prints would never be so gorgeous!

Thank you, Aline Lemos, Mayra V. V. A. Dutra, Nádia Vieira, Whitney Thore, and Emilly Mel, for being great inspirations—and the only actual "real women" of the *Women* project. Thank you, Samie Carvalho, for letting me use your character, Sasha the Lioness, in the Sasha illustration. Also, another special thanks to Aline, who's my Badass Feminist Guru and helped me so much in so many ways with this project.

Thank you, Mey Rude, for letting me base the Suki illustration on one of your texts!

Thank you, Skyhorse and my editor Nicole Frail, for believing in this project!

Thank you to everybody who's been helping me with the translations to so many languages that I lost count! Thanks to you all, this project has spread all over the Internet and reached so many people.

Thank you, my partners at Café com Chocolate Design, who were supportive and understanding when I needed some time off to work on this book.

Thank you to my amazing friends, who didn't give up on me when I couldn't go out because I was drawing. Thank you for understanding and supporting me when we were together and especially when we were not. And a special thanks to Ane and Deks, who brought me food when I was drawing like crazy and didn't have time to cook.

Thank you, my family, for supporting me so much during my whole life. Thank you, Mom and Dad, for not taking away my colored pencils when I started drawing on my bedroom walls at the age of three, and for always encouraging me to work with what I love.

Thank you, Vó Tetê, for inspiring me so much and for correcting my poor grammar (in Portuguese). Thank you, my in-laws, for your love and support. Thank you to everybody who felt touched by my work. You have shared and reblogged *WOMEN* and made it stronger every day. Without you, nothing would have developed the way it did. This book is for you.